BARBADOS

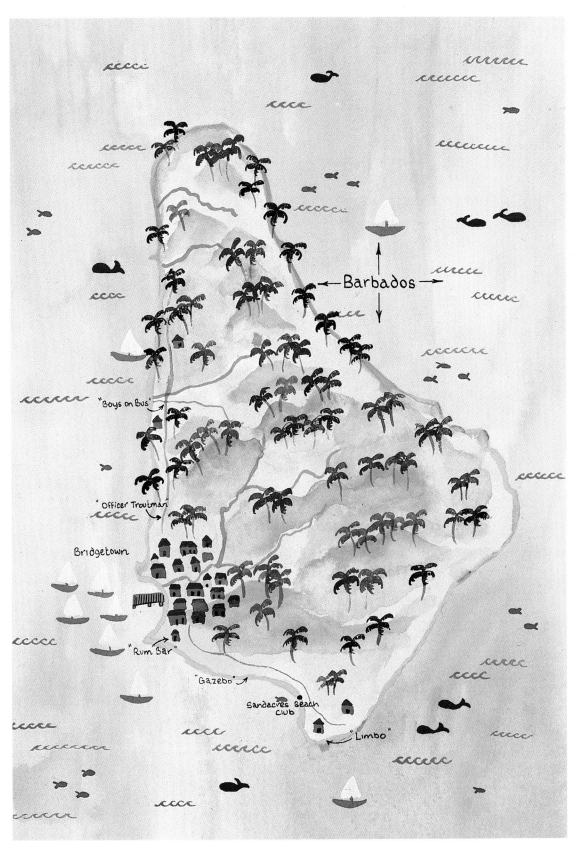

Barbados, Gouache on Paper, 16 × 11 inches

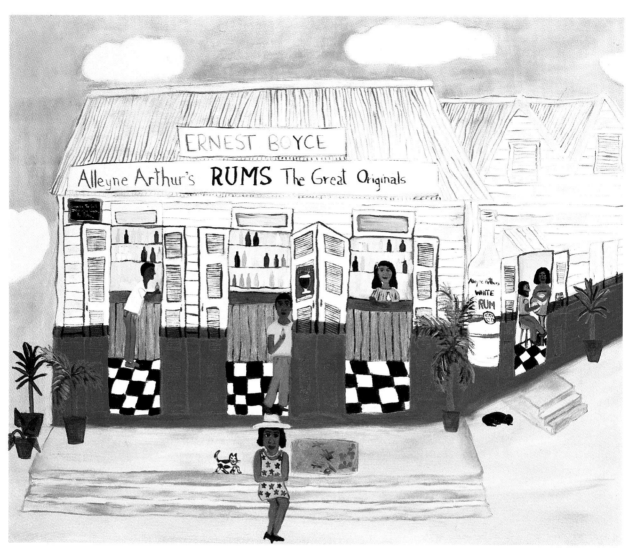

Rum Bar, Oil on Canvas Board, 25 × 30 inches

The Song of the Banana Man

Down at de bar near United Wharf
We knock back a white rum, bus' a laugh,
Fill de empty bag for further toil
Wid saltfish, breadfruit, coconut oil.

Evan Jones

CARIBBEAN CANVAS

Frané Lessac

MACMILLAN CARIBBEAN

For Mark and our new little one,
 who stayed in me belly
 till this was done . . .

Very special thanks are due to the following Caribbean hotels which helped me with my trip: The Antigua Village in Antigua; the Accra Beach in Barbados; the Twelve Degrees North in Grenada; and the Palm Island Beach Club in Palm Island.

Sincere thanks also to Jane Sonachan at William Galley Associates in London which represents all of these properties in the UK.

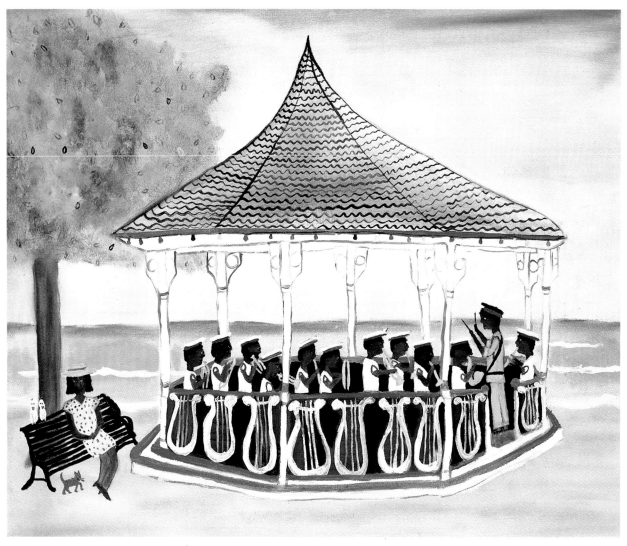

Gazebo, Oil on Canvas Board, 20 × 24 inches

A military band proud and strong
Fills the salty air with a national song
Uniforms and instruments shine in the sun
And beat to the heart of a solitary one.

Marcus Wayne

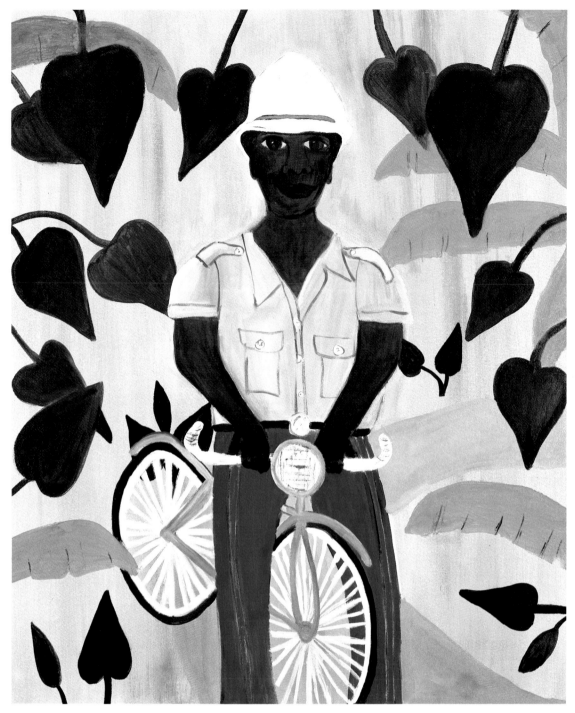

Officer Troutman, Oil on Canvas Board, 30 × 25 inches

'Break master neck but nuh break master law.'
Respect the law.

West Indian proverb

The bus weaves its way through the jungle home
me and my brother all alone
so tired are we from schoolyard play
lean on me bro', at the end of the day.

Marcus Wayne

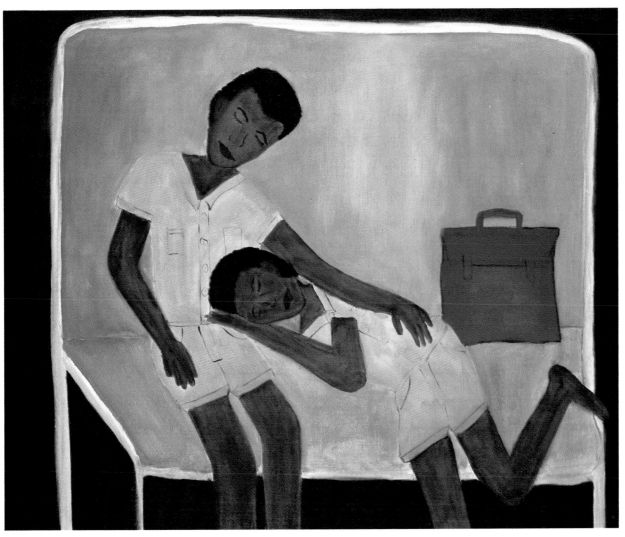

Boys on the Bus, Oil on Canvas Board, 25 × 30 inches

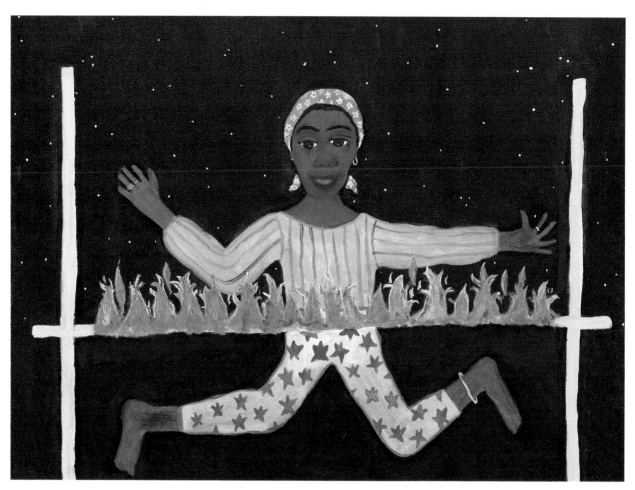

Limbo, Oil on Canvas Board, 22 × 30 inches

'Caliban' Limbo

limbo
limbo like me

drum stick knock
and the darkness is over me

knees spread wide
and the water is hiding me

limbo
limbo like me

knees spread wide
and the dark ground is under me

down
down
down

and the drummer is calling me.

Edward Brathwaite

ANTIGUA

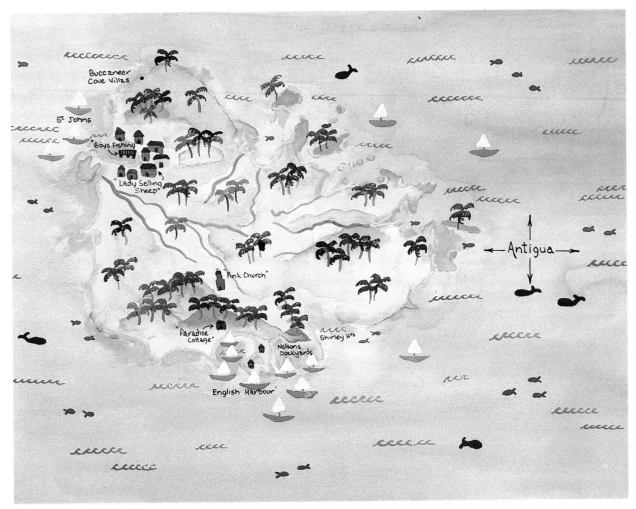

Buccaneer
Cove Villas

St. Johns

Boys Fishing

'Lady Selling
Sheep'

Pink Church

←Antigua→

Paradise
Cottage'

Nelsons
Dockyards

Shirley H^ts

English Harbour

Antigua, Gouache on Paper, 11 × 16 inches

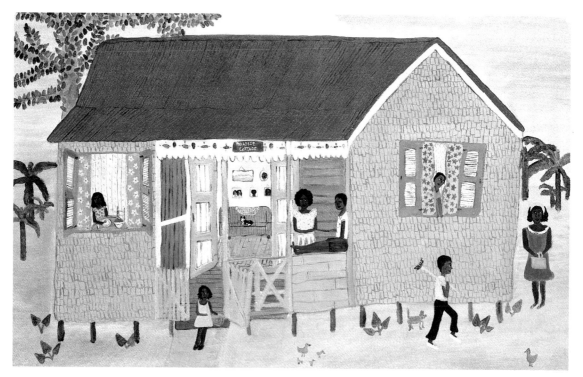

Paradise Cottage, Oil on Canvas Board, 22 × 30 inches

An old Jamaican woman thinks about the hereafter

I have looked
up at the stars from my front verandah and have been afraid
of their pathless distances. I have never flown
in the loud aircraft nor have I seen palaces,
so I would prefer not to be taken up high nor
rewarded with a large mansion.

A L Hendricks

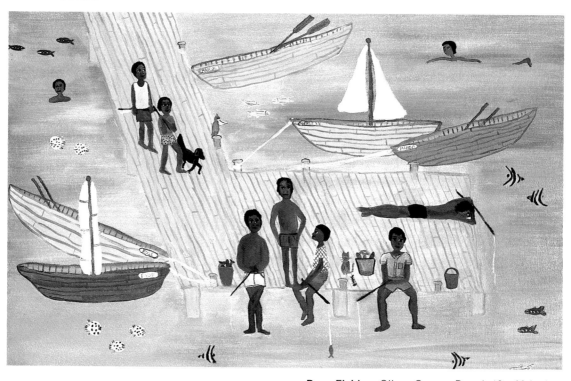

Boys Fishing, Oil on Canvas Board, 18 × 26 inches

Ilan' Life

Ilan' life ain' no fun less ya treat errybody
Like ya brudder, ya sister, or ya frien'
Love ya neighbour, play ya part, jes remember
das de art
For when ocean fence ya in, all is kin.

Susan J Wallace 10

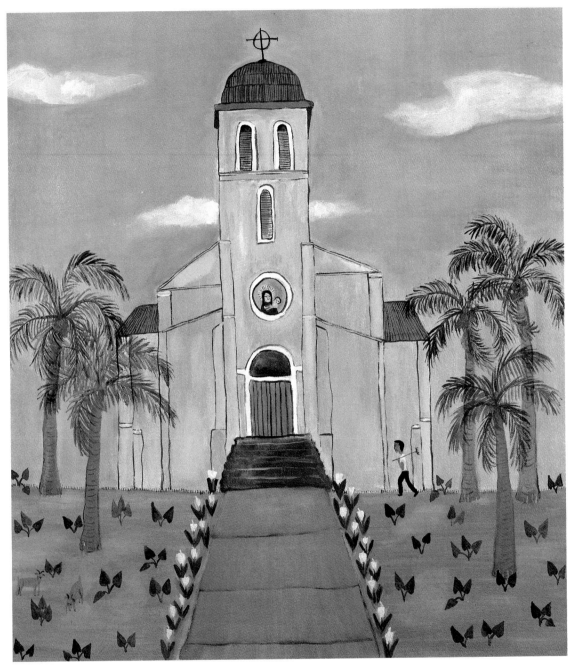

Pink Church, Oil on Canvas Board, 24 × 20 inches

An old Jamaican woman thinks about the hereafter

What would I do forever in a big place, who
have lived all my life in a small island?
The same parish holds the cottage I was born in, all
my family, and the cool churchyard.

A L Hendricks

11

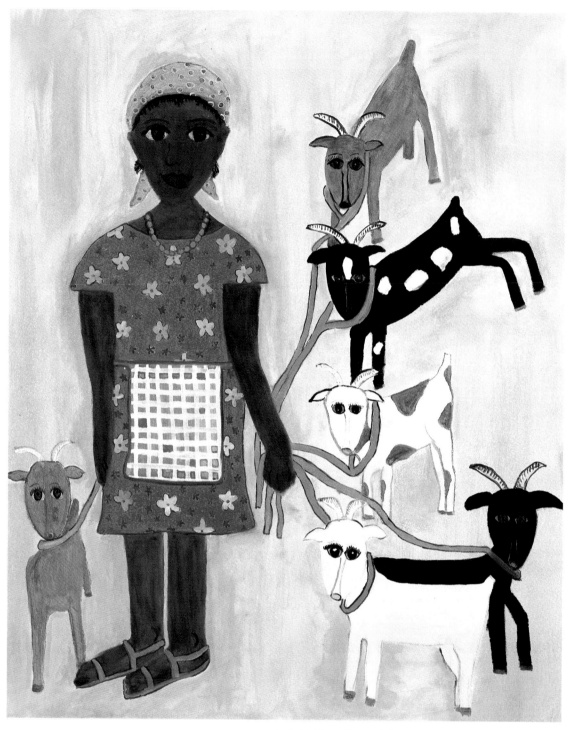

Lady Selling Sheep, Oil on Canvas Board, 30 × 25 inches

The Song of the Banana Man

Up in de hills, where the streams are cool,
Where mullet an' janga swim in de pool,
I have ten acres of mountain side,
An' a dainty-foot donkey dat I ride,
Four Gros Michel, an' four Lacatan,
Some coconut trees, and some hills of yam,
An' I pasture on dat very same lan'
Five she-goats an' a big black ram.

Evan Jones

ST KITTS, NEVIS AND REDONDA

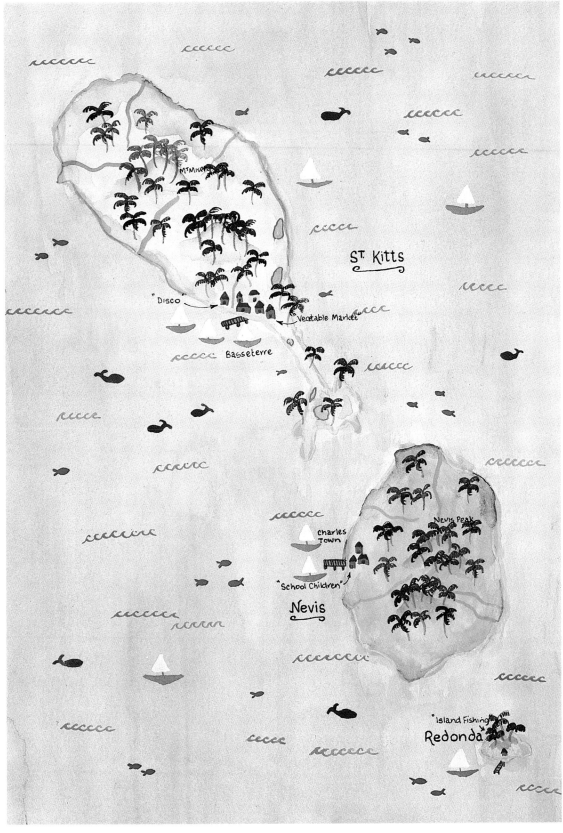

St. Kitts

M^t Misery

"Disco" →

Vegtable Market

Basseterre

Charles Town

"School Children"

Nevis

Nevis Peak

"Island Fishing"
Redonda

St Kitts, Nevis and Redonda, Gouache on Paper, 16 × 11 inches

'Pumpkin neba bear water-melan.'
Children resemble parents.

West Indian proverb

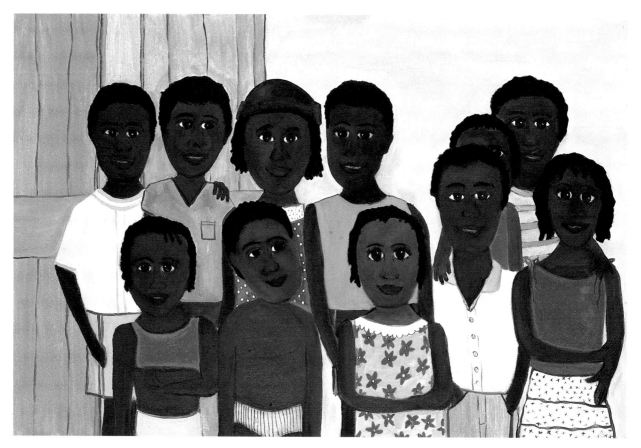

Day Care Centre, Oil on Canvas Board, 20 × 30 inches

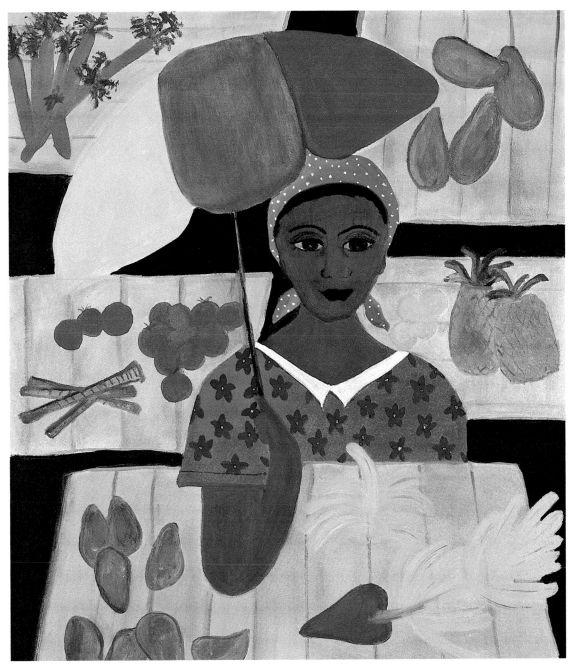

Vegetable Market, Oil on Canvas Board, 30 × 25 inches

Market Women

Down from the hills, they come
With swinging hips and steady stride
To feed the hungry town.
They stirred the steep dark land
To place within the growing seed.
And in the rain and sunshine
Tended the young green plants,
They bred, and dug and reaped.
And now, as Heaven has blessed their toil,
They come, bearing the fruits,
These hand-maids of the soil,
Who bring baskets down,
To feed the hungry town.

Daisy Myrie

15

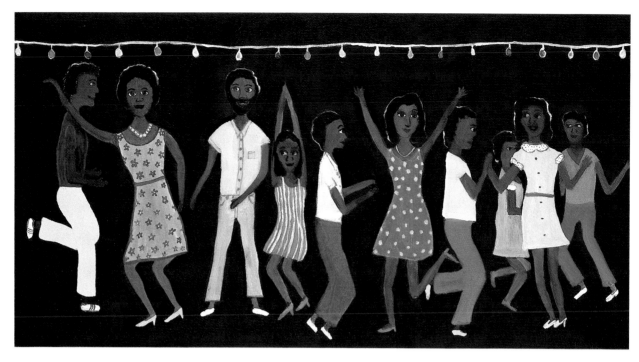

The colours are placed like music, side by side, note by note,
they must complement and flow. The composition is like a dance, a ballet,
it must be choreographed and timed, a form cannot enter too soon or step out of place.
I want my paintings to leap out, draw you in, and tickle your retinas.

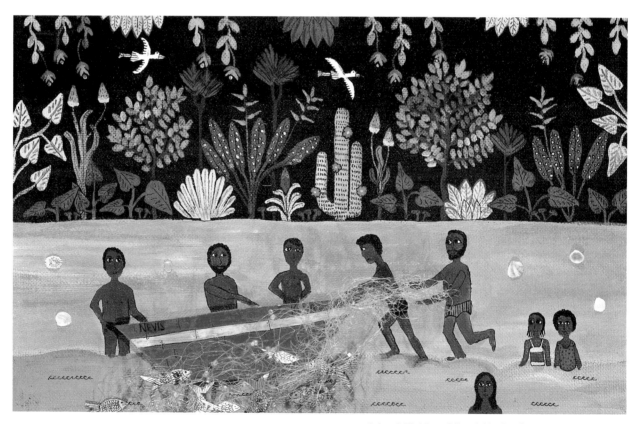

South

But today I recapture the islands'
bright beaches blue mist from the ocean
rolling into fishermen's houses.
By these shores I was born: sound of the sea
came in at my window, life heaved and breathed
in me then with the strength of that
turbulent soil.

Edward Brathwaite

16

GRENADA

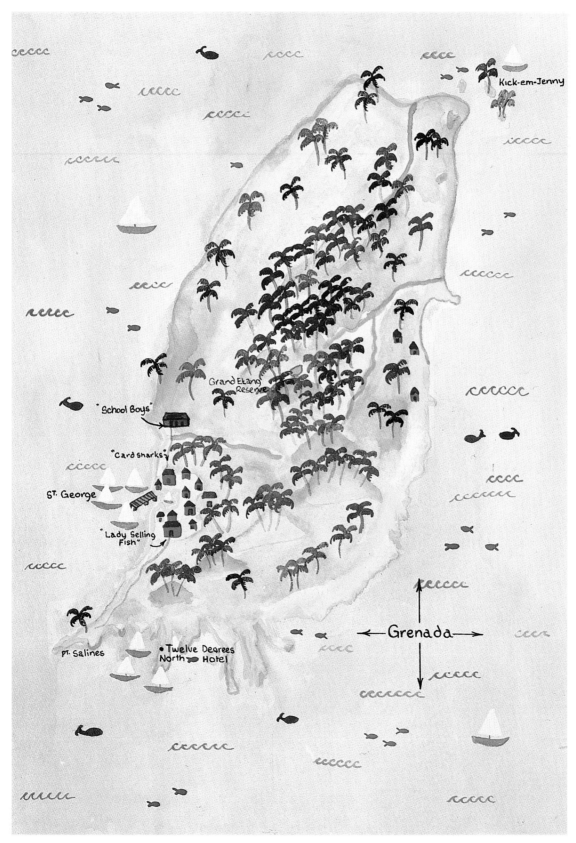

Grenada, Gouache on Paper, 11 × 16 inches

Diamonds, hearts, kings and aces
cards and coins and familiar faces
The old wooden table
has seen smiles and tears
of gamblers' fortunes
throughout the years.

Marcus Wayne

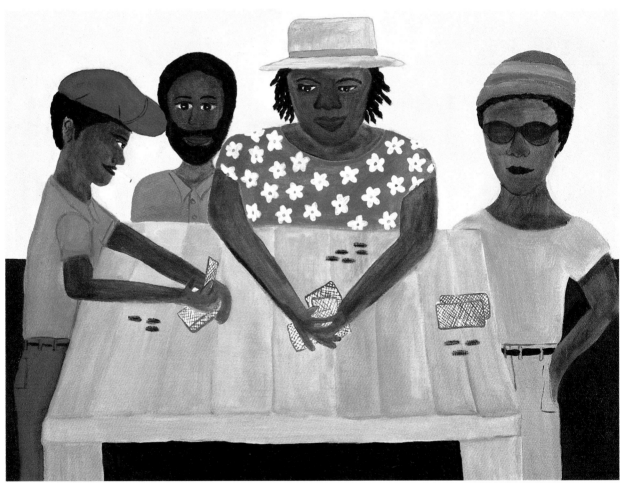

Cardsharks, Oil on Canvas Board, 22 x 30 inches

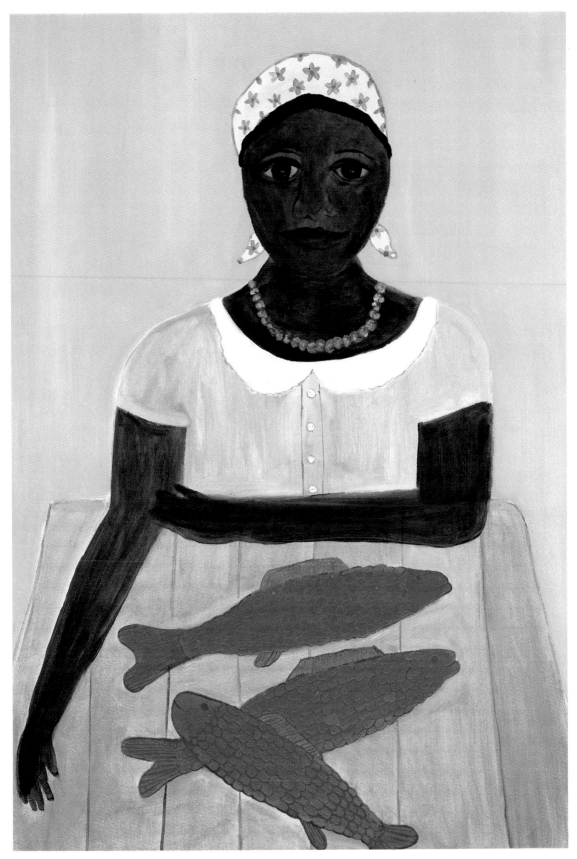

Lady Selling Fish, Oil on Canvas Board, 30 × 22 inches

The artist's challenge is to evoke
the senses of sight, sound and smell
on to a piece of paper or canvas.
What a challenge.

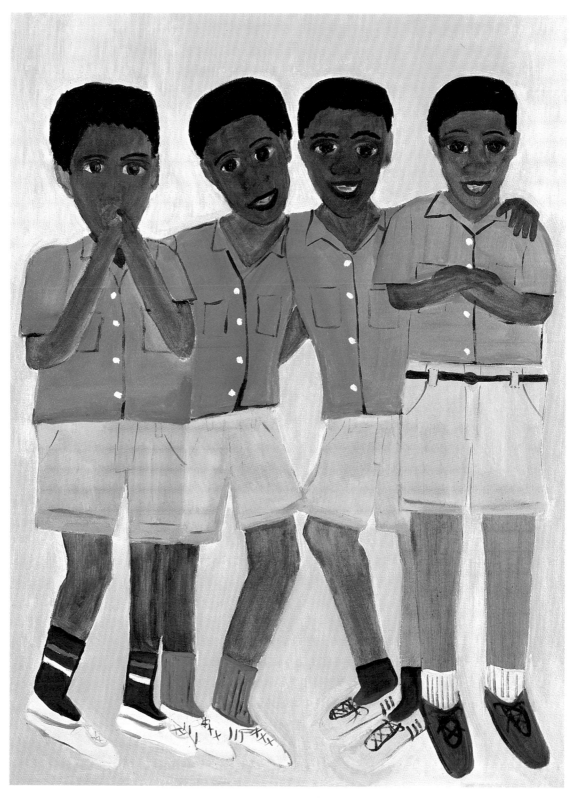

Schoolboys, Oil on Canvas Board, 30 × 25 inches

Jamaican Alphabet

A fe ackee, salt fish bes' frien, an'
B fe bammy, banana an' den
C fe coco an' callalloo, an'
D is fe dumplin an' duckanoo, duckanoo.

Louise Bennett

PALM ISLAND, MAYREAU, UNION ISLAND AND THE TOBAGO CAYS

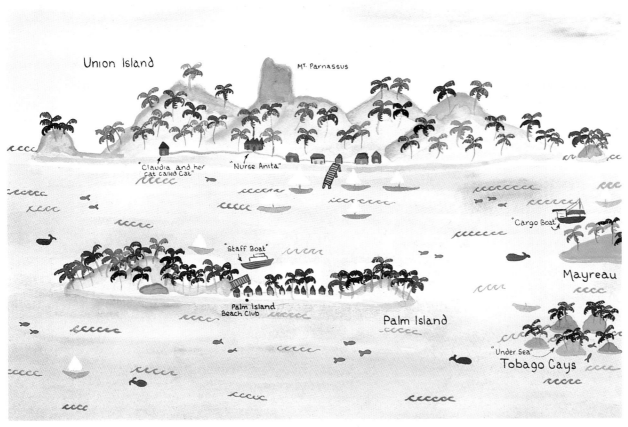

The Islands, Gouache on Paper, 11 × 16 inches

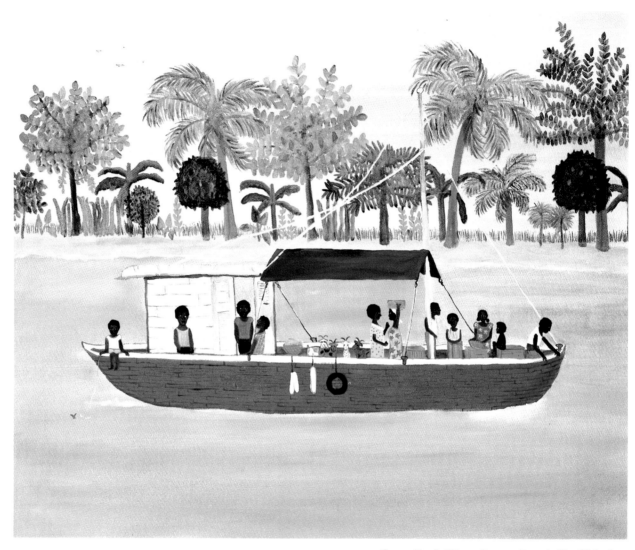

Cargo Boat, Oil on Canvas Board, 25 × 30 inches

I am a West Indian
for the raging love
I have
for the beach
and the sea
and the sweet smell
of the salt wind
and winding, windy sea.

Robert Johnson

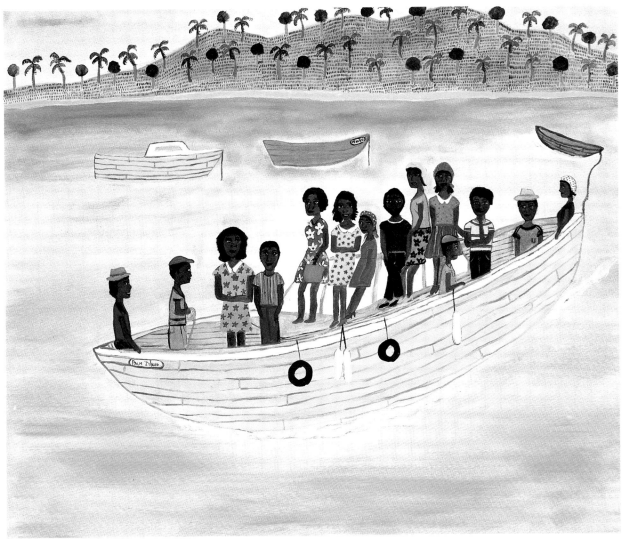

Staff Boat, Oil on Canvas Board, 25 × 30 inches

The crackle birds wake up at the crack of dawn
Palm tree tops already golden with the sun.
I arise and run on the white coral sands, the sea tickling my toes.

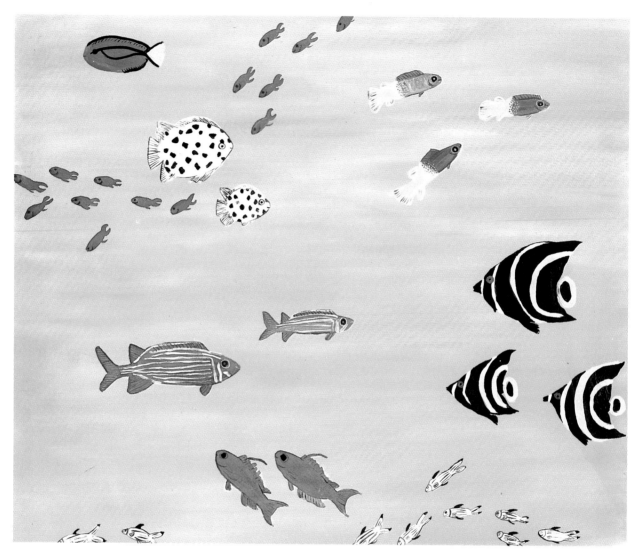

Undersea, Oil on Canvas, 36 × 40 inches

Sea School

So for an hour, an age, I swam with them,
One with a peace that might go on forever . . .
Till, of a sudden, quick as a falling net,
Some thought embraced them. I watched them go
Tidily over the reef, where I could not follow.

Barbara Howes

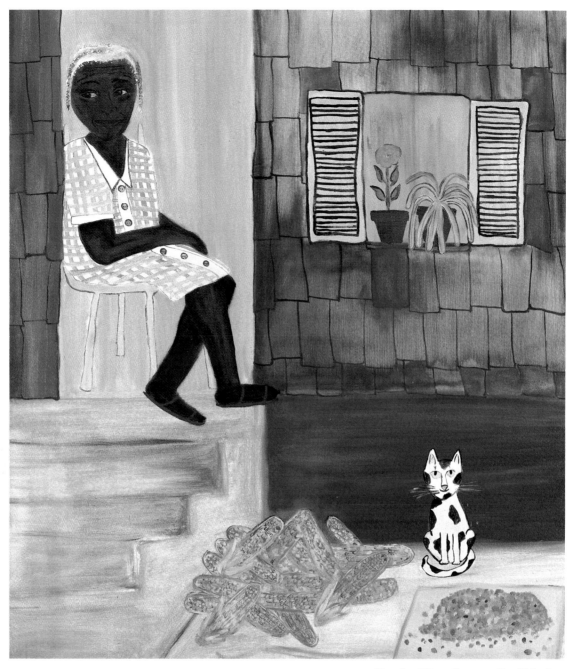

Claudia, Oil on Canvas, 40 × 36 inches

Heaven on earth
hiking to a small small village in the south
where I met Claudia with her corn
and a cat called Cat.

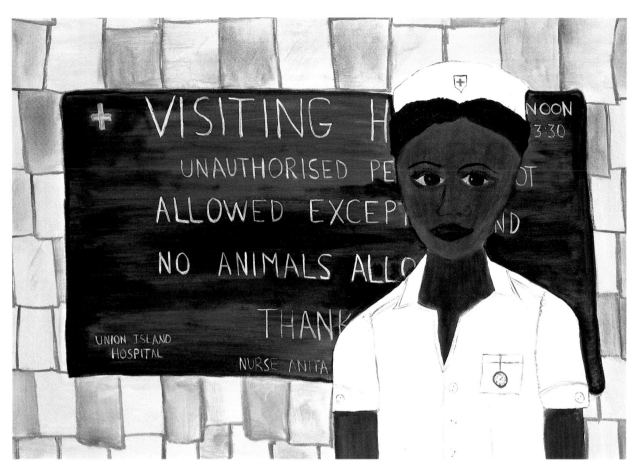

Nurse Anita, Oil on Canvas Board, 20 × 30 inches

'Sickness come di gallop, but e tek e own time fo walk' way.'
Sickness comes suddenly, but goes slowly.

West Indian Proverb

MONTSERRAT

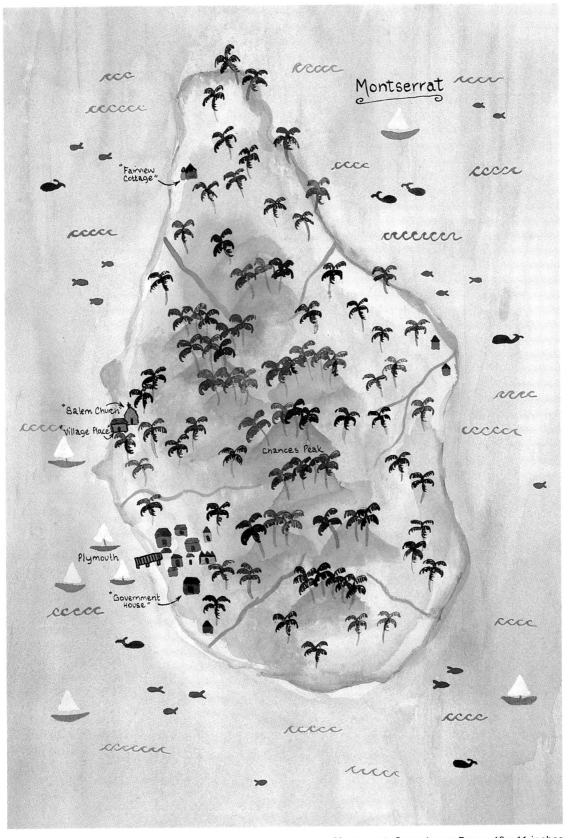

Montserrat, Gouache on Paper, 16 × 11 inches

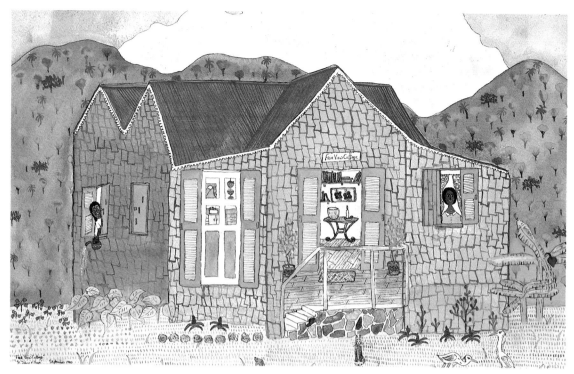

Fairview Cottage, Gouache on Paper, 11 × 15 inches

The locals would say to me
'you live in de cement house, and no worry de hurricane.'
And my feelings were torn as the houses were torn down.
I wish there was a house museum.

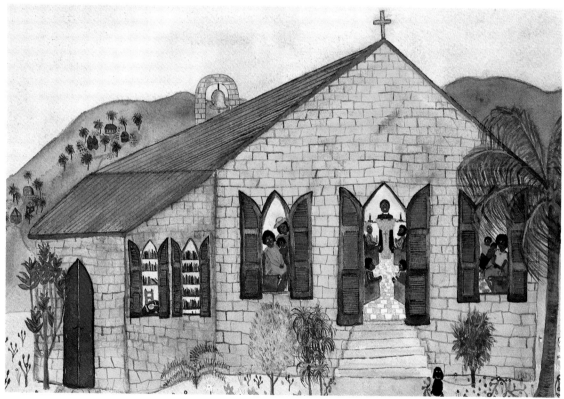

Salem Church, Watercolour on Paper, 12 × 16 inches

The Hymn Tunes

I sang off-key on Low Church, tropical
Sunday mornings; organ swept, never doubted
That the sure tunes had reason to be sure,
That some great good would come of what I shouted.
Later, across the sea, I sang in a tall
Gothic cathedral, where all sounds endure.

Edward Lucie-Smith

28

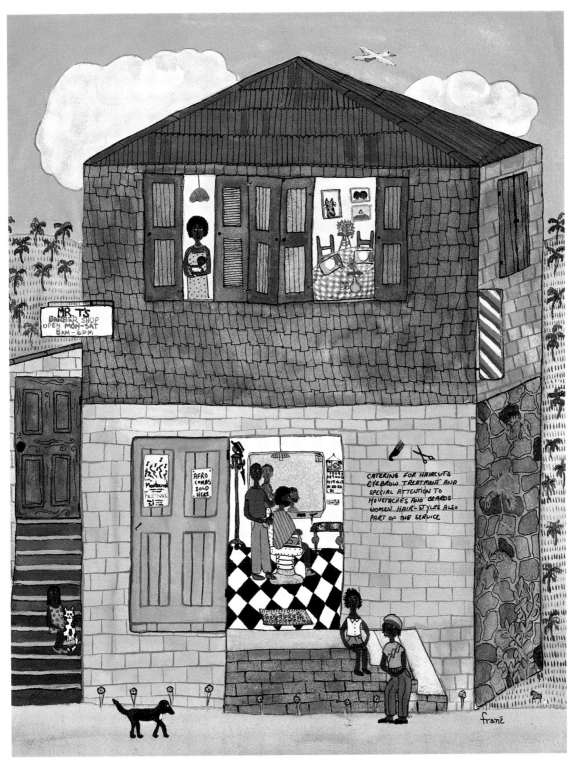

Mr. T's Barber Shop, Gouache on Paper, 15 x 11 inches

Kinky Hair Blues

Lord 'tis you did gie me
All dis kinky hair.
'Tis you did gie me
All dis kinky hair,
And I don't envy gals
What got dose locks so fair.

Una Marson

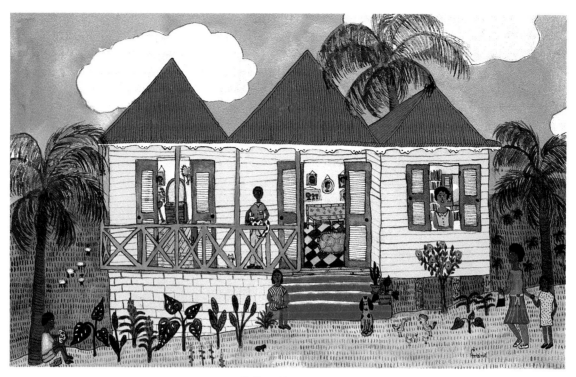

Yellow House on Wall Street, Gouache on Paper, 10 × 14 inches

Corrugated hillsides
Leaping in giddy jumps
Towards the cloud-speckled sky.

Norman Buffonge

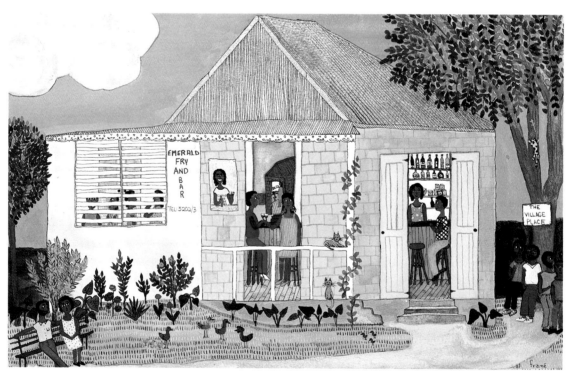

The Village Place, Gouache on Paper, 11 × 15 inches

This time, from across the water
I found Blondella gone.
Beautiful brown Blondella
who between selling rum and rotis
sipped at her favourite gin and tonic
staggering slightly in the sun.
But now gone.
(Some say) Miami. Antigua.
Across the water (somewhere).

Aleph Kamal

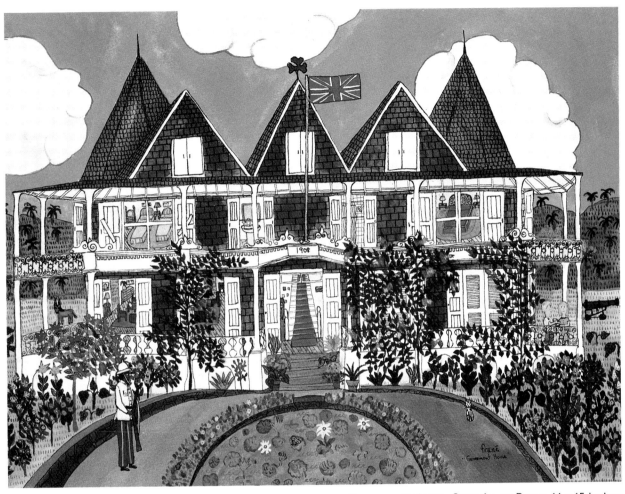

Government House, Gouache on Paper, 11 × 15 inches

I love having the liberty as a painter, to paint a wishful scenario of what I see.
There is so much to life and I'm trying to catch a breath of it on paper.
The small details that one hardly notices.
The lizard in the grass, the pattern on a woman's dress, the paintings on a wall, even what's around the corner

First published 1987

Published by *Macmillan Publishers Ltd*
London and Basingstoke
Associated companies and representatives in Accra,
Auckland, Delhi, Dublin, Gaborone, Hamburg, Harare,
Hong Kong, Kuala Lumpur, Lagos, Manzini, Melbourne,
Mexico City, Nairobi, New York, Singapore, Tokyo

ISBN 0-333-44553-8

Printed in Hong Kong

British Library Cataloguing in Publication Data
Lessac, Frané
 Caribbean canvas.
 1. Lessac, Frané 2. Caribbean area in art
 I. Title
 759.13 ND237.L5/

ISBN 0-333-44553-8

Acknowledgements

PAINTINGS
For permission to publish or reproduce the Paintings in this book grateful acknowledgement is made
to the following:
'The Village Place' and 'Island Fishing': Mr Aleph Kamal
'Disco': Ms Jane Parfet
'Yellow House on Wall St' and 'Mr T's Barber Shop': Mr Chris Thomas
'Fairview Cottage': Mrs Beverley Hendershott
'Salem Church': Fowler-Mills Gallery
'Government House': Mr and Mrs J Astley

POETRY
The author and publishers wish to thank the following who have kindly given permission for the
use of copyright material:—
Aleph Kamal for his poem 'The Village Place'.
Oxford University Press for 'Caliban' from *Islands* by Edward Kamau Brathwaite (1969), and with
Doubleday & Company Inc. for an extract from 'South' by Edward Kamau Brathwaite.
Douglas Rae (Management) Ltd. on behalf of Evan Jones for an extract from 'The Song of the Banana
Man'.
Edward Lucie-Smith for an extract from 'The Hymn Tunes'.
Marcus Wayne for his poems 'The Old Wooden Table', 'Schooldays' and 'The Band'.
Every effort has been made to trace all the copyright holders but if any have been inadvertently
overlooked the publishers will be pleased to make the necessary arrangement at the first opportunity.